The Unstrung Harp;

or,

Mr Earbrass Writes a Novel.

By

Edward Gorey

HARCOURT BRACE & COMPANY
New York San Diego London

Library of Congress Cataloging-in-Publication Data
Gorey, Edward, 1925-
The unstrung harp, or, Mr. Earbrass writes a novel/by Edward Gorey.
p. cm.
ISBN 0-15-100435-8
I. Title. II. Title: Unstrung harp. III. Title: Mr. Earbrass writes a novel.
PS3557.0753U55 1999
813'.54—DC21 98-45487

Printed in Singapore
A C E F D B

Mr C(lavius) F(rederick) Earbrass is, of course, the well-known novelist. Of his books, *A Moral Dustbin, More Chains Than Clank, Was It Likely?* , and the Hipdeep trilogy are, perhaps, the most admired. Mr Earbrass is seen on the croquet lawn of his home, Hobbies Odd, near Collapsed Pudding in Mortshire. He is studying a game left unfinished at the end of summer.

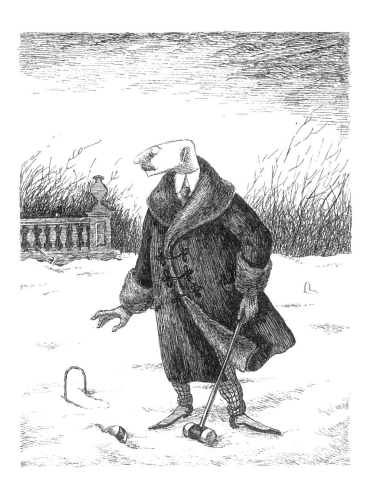

On November 18th of alternate years Mr Ear-brass begins writing 'his new novel'. Weeks ago he chose its title at random from a list of them he keeps in a little green note-book. It being tea-time of the 17th, he is alarmed not to have thought of a plot to which *The Unstrung Harp* might apply, but his mind will keep reverting to the last biscuit on the plate.

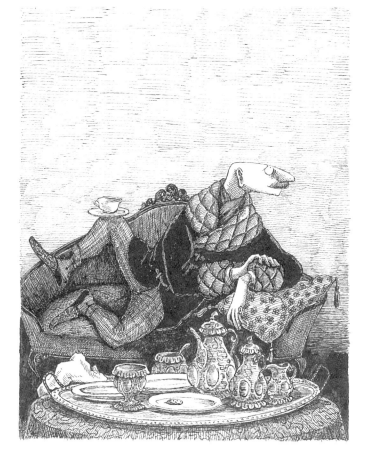

Snow was falling when Mr Earbrass woke, which suggested he open *TUH* with the first flakes of what could be developed into a prolonged and powerfully purple blizzard. On paper, if not outdoors, they have kept coming down all afternoon, over and over again, in all possible ways; and only now, at nightfall, have done so satisfactorily. For writing Mr Earbrass affects an athletic sweater of forgotten origin and unknown significance; it is always worn hindside-to.

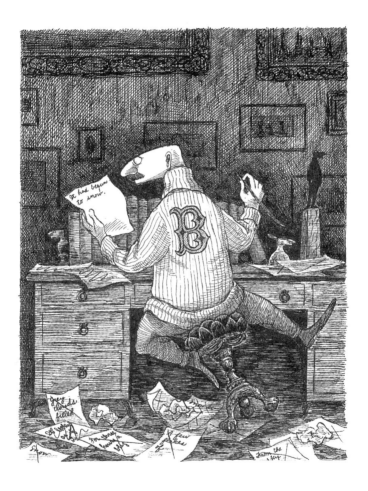

Several weeks later, the loofah trickling on his knees, Mr Earbrass mulls over an awkward retrospective bit that ought to go in Chapter II. But where? Even the voice of the omniscient author can hardly afford to interject a seemingly pointless anecdote concerning Ladderback in Tibet when the other characters are feverishly engaged in wondering whether to have the pond at Disshiver Cottage dragged or not.

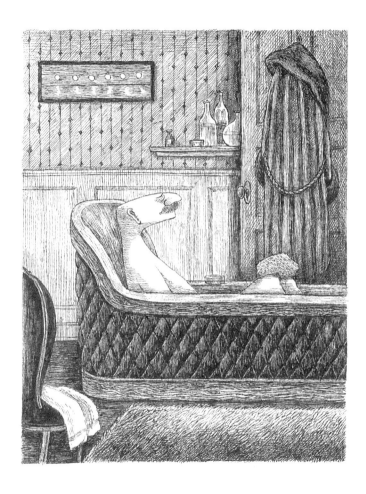

Mr Earbrass belongs to the straying, rather than to the sedentary, type of author. He is never to be found at his desk unless actually writing down a sentence. Before this happens he broods over it indefinitely while picking up and putting down again small, loose objects; walking diagonally across rooms; staring out windows; and so forth. He frequently hums, more in his mind than anywhere else, themes from the Poddington *Te Deum*.

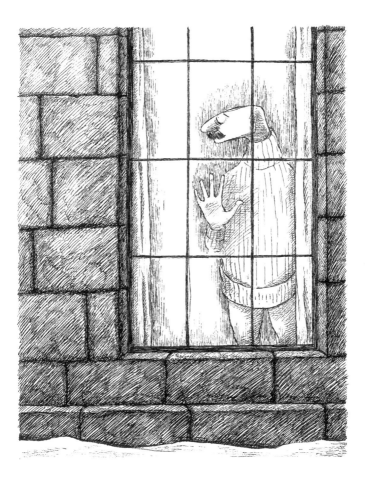

It was one of Mr Earbrass's better days; he wrote for so long and with such intensity that when he stopped he felt quite sick. Having leaned out a window into a strong wind for several minutes, he is now restoring himself in the kitchen and rereading *TUH* as far as he has gotten. He cannot help but feel that Lirp's return and almost immediate impalement on the bottle-tree was one of his better ideas. The jelly in his sandwich is about to get all over his fingers.

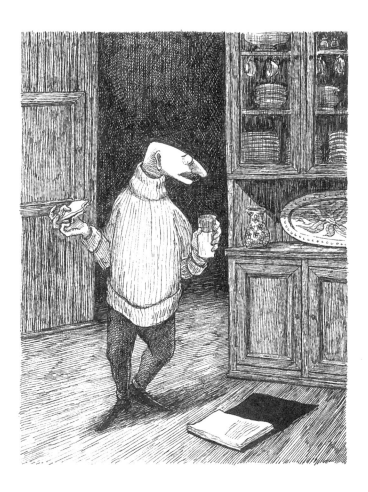

Mr Earbrass has finished Chapter VII, and it is obvious that before plunging ahead himself he has got to decide where the plot is to go and what will happen to it on arrival. He is engaged in making diagrams of possible routes and destinations, and wishing he had not dealt so summarily with Lirp, who would have been useful for taking retributive measures at the end of Part Three. At the moment there is no other character capable of them.

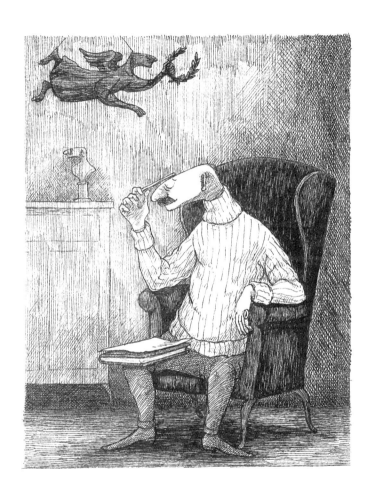

Out for a short drive before a supper of oysters and trifle, Mr Earbrass stops near the abandoned fireworks factory outside Something Awful. There is a drowned sort of yellow light in the west, and the impression of desolation and melancholy is remarkable. Mr Earbrass jots down a few visual notes he suspects may be useful when he reaches the point where the action of *TUH* shifts to Hangdog Hall.

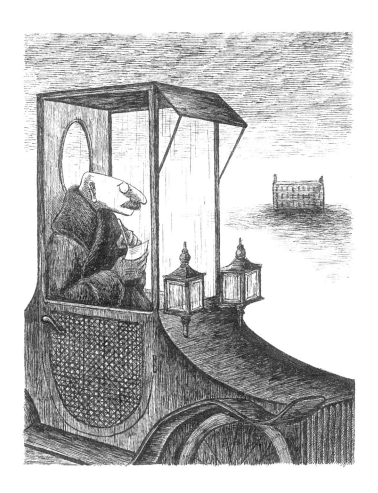

Mr Earbrass was virtually asleep when several lines of verse passed through his mind and left it hopelessly awake. Here was the perfect epigraph for *TUH*:

> *A horrid ?monster has been [something]*
> *delay'd*
> *By your/their indiff'rence in the dank brown*
> *shade*
> *Below the garden . . .*

His mind's eye sees them quoted on the bottom third of a right-hand page in a (possibly) olive-bound book he read at least five years ago. When he does find them, it will be a great nuisance if no clue is given to their authorship.

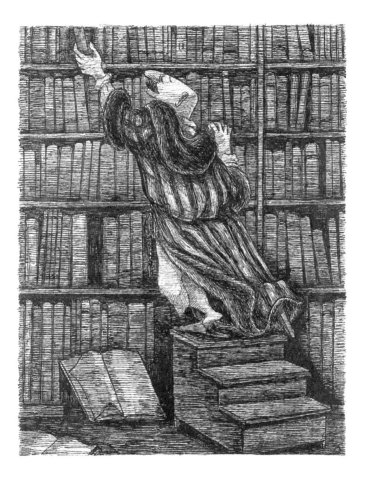

Mr Earbrass has driven over to Nether Millstone in search of forced greengages, but has been distracted by a bookseller's. Rummaging among mostly religious tracts and privately printed reminiscences, he has come across *The Meaning of the House*, his second novel. In making sure it has not got there by mistake (as he would hardly care to pay more for it), he discovers it is a presentation copy. *For Angus — will you ever forget the bloaters?* Bloaters? Angus?

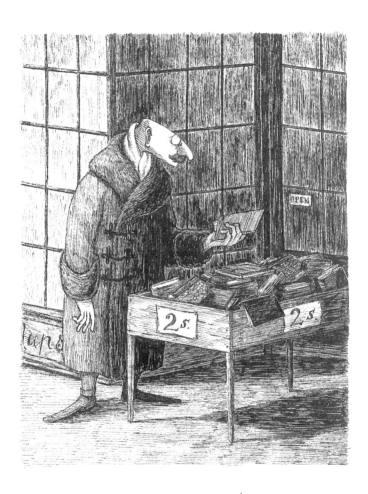

The first draft of *TUH* is more than half finished, and for some weeks its characters have been assuming a fitful and cloudy reality. Now, a minor one named Glassglue has materialized at the head of the stairs as his creator is about to go down to dinner. Mr Earbrass was aware of the peculiarly unpleasant nubs on his greatcoat, but not the blue-tinted spectacles. Glassglue is about to mutter something in a tone too low to be caught and, stepping sideways, vanish.

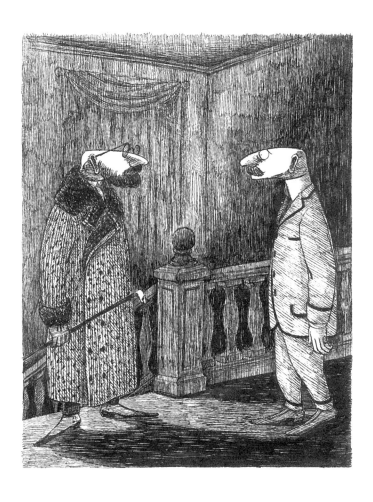

Mr Earbrass has rashly been skimming through the early chapters, which he has not looked at for months, and now sees *TUH* for what it is. Dreadful, *dreadful*, DREADFUL. He must be mad to go on enduring the unexquisite agony of writing when it all turns out drivel. Mad. Why did n't he become a spy? How does one become one? He will burn the MS. Why is there no fire? Why are n't there the makings of one? How did he get in the unused room on the third floor?

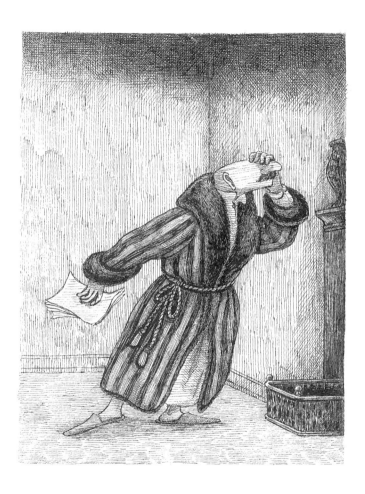

Mr Earbrass returned from a walk to find a large carton blocking the hall. Masses of brown paper and then tissue have reluctantly given up an unnerving silver-gilt combination epergne and candelabrum. Mr Earbrass recollects a letter from a hitherto unknown admirer of his work, received the week before; it hinted at the early arrival of an offering that embodied, in a different but kindred form, the same high-souled aspiration that animated its recipient's books. Mr Earbrass can only conclude that the apathy of the lower figures is due to their having been deprived of novels.

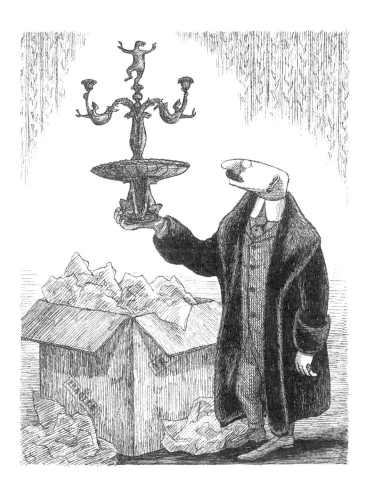

Even more harrowing than the first chapters of a novel are the last, for Mr Earbrass anyway. The characters have one and all become thoroughly tiresome, as though he had been trapped at the same party with them since the day before; neglected sections of the plot loom on every hand, waiting to be disposed of; his verbs seem to have withered away and his adjectives to be proliferating past control. Furthermore, at this stage he inevitably gets insomnia. Even rereading *The Truffle Plantation* (his first novel) does not induce sleep. In the blue horror of dawn the vines in the carpet appear likely to begin twining up his ankles.

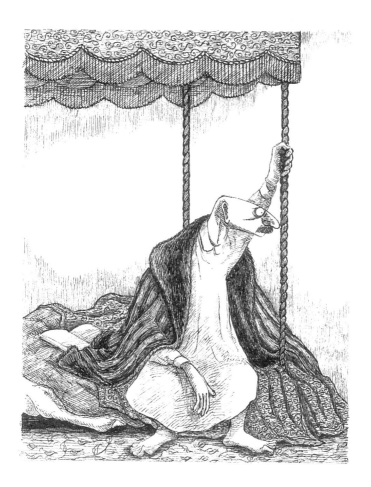

Though *TUH* is within less than a chapter of completion, Mr Earbrass has felt it his cultural and civic duty, and a source of possible edification, to attend a performance at Lying-in-the-Way of Prawne's *The Nephew's Tragedy*. It is being put on, for the first time since the early seventeenth century, by the West Mortshire Impassioned Amateurs of Melpomene. Unfortunately, Mr Earbrass is unable to take in even one of its five plots because he cannot get those few unwritten pages out of his mind.

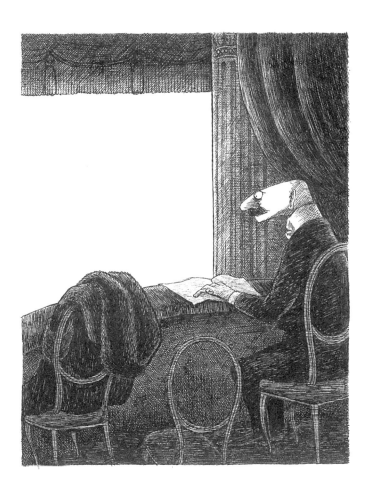

In that brief moment between day and night, when everything seems to have stopped for good and all, Mr Earbrass has written the last sentence of *TUH*. The room's appearance of tidiness and Mr Earbrass's of calm are alike deceptive. The MS is stuffed all anyhow in the lower right-hand drawer of the desk, and Mr Earbrass himself is wildly distrait. His feet went to sleep some time ago, there is a dull throbbing behind his left ear, and his moustache feels as uncomfortable as if it were false, or belonged to someone else.

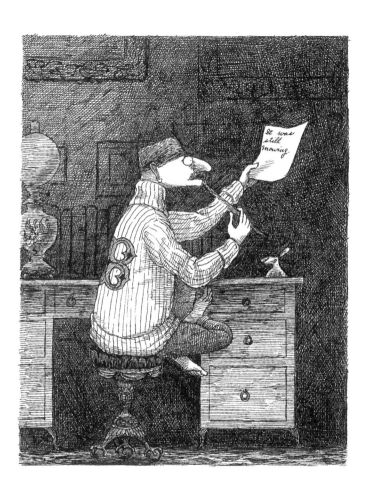

The next day Mr Earbrass is conscious but very little more. He wanders through the house, leaving doors open and empty tea-cups on the floor. From time to time the thought occurs to him that he really ought to go and dress, and he gets up several minutes later, only to sit down again in the first chair he comes to. The better part of a week will have elapsed before he has recovered enough to do anything more helpful.

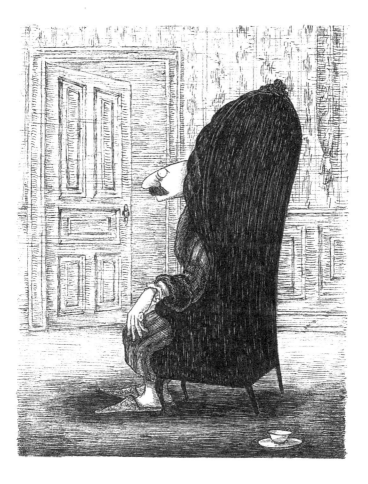

Some weeks later, with pen, ink, scissors, paste, a decanter of sherry, and a vast reluctance, Mr Earbrass begins to revise *TUH*. This means, first, transposing passages, or reversing the order of their paragraphs, or crumpling them up furiously and throwing them in the waste-basket. After that, there is rewriting. This is worse than merely writing, because not only does he have to think up new things just the same, but at the same time try not to remember the old ones. Before Mr Earbrass is through, at least one third of *TUH* will bear no resemblance to its original state.

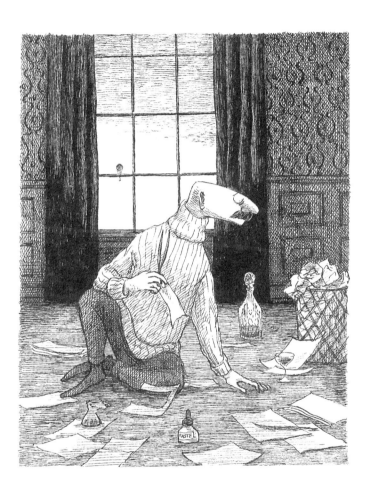

Mr Earbrass sits on the opposite side of the study from his desk, gathering courage for the worst part of all in the undertaking of a novel, i.e., making a clean copy of the final version of the MS. Not only is it repulsive to the eye and hand, with its tattered edges, stains, rumpled patches, scratchings-out, and scribblings, but its contents are, by this time, boring to the point of madness. A freshly-filled inkwell, new pheasant-feather pens, and two reams of the most expensive cream laid paper are negligible inducements for embarking on such a loathsome proceeding.

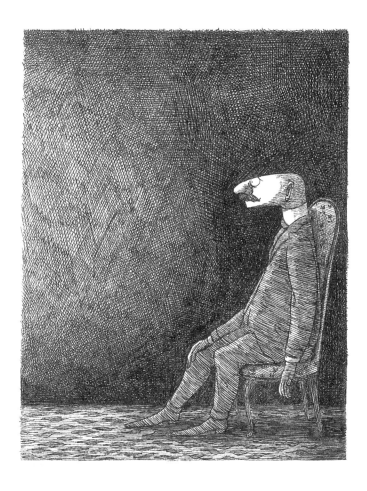

Holding *TUH* not very neatly done up in pink butcher's paper, which was all he could find in a last-minute search before leaving to catch his train for London, Mr Earbrass arrives at the offices of his publishers to deliver it. The stairs look oddly menacing, as though he might break a leg on one of them. Suddenly the whole thing strikes him as very silly, and he thinks he will go and drop his parcel off the Embankment and thus save everyone concerned a good deal of fuss.

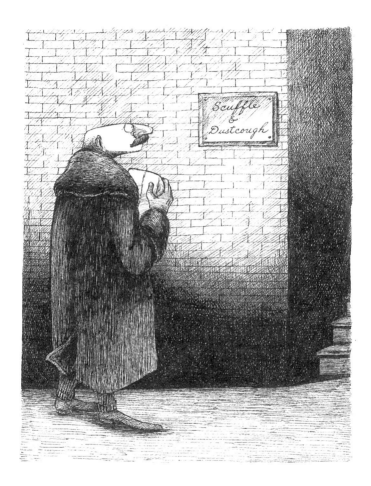

Mr Earbrass escaped from Messrs Scuffle and Dustcough, who were most anxious to go into all the ramifications of a scheme for having his novels translated into Urdu, and went to call on a distant cousin. The latter was planning to do the antique-shops this afternoon, so Mr Earbrass agreed to join him. In the eighteenth shop they have visited, the cousin thinks he sees a rare sort of lustre jug, and Mr Earbrass irritatedly wonders why anyone should have had a fantod stuffed and put under a glass bell.

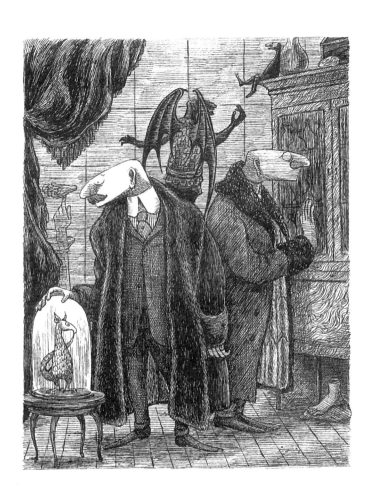

The night before returning home to Mortshire Mr Earbrass allows himself to be taken to a literary dinner in a private dining room of Le Trottoir Imbécile. Among his fellow-authors, few of whom he recognizes and none of whom he knows, are Lawk, Sangwidge, Ha'p'orth, Avuncular, and Lord Legbail. The unwell-looking gentleman wrapped in a great-coat is an obscure essayist named Frowst. The talk deals with disappointing sales, inadequate publicity, worse than inadequate royalties, idiotic or criminal reviews, others' declining talent, and the unspeakable horror of the literary life.

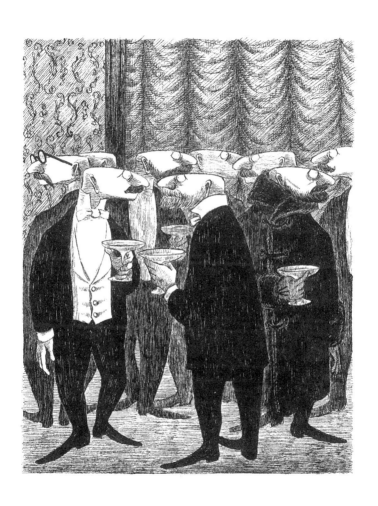

TUH is over, so to speak, but far from done with. The galleys have arrived, and Mr Earbrass goes over them with mingled excitement and disgust. It all looks so different set up in type that at first he thought they had sent him the wrong ones by mistake. He is quite giddy from trying to physically control the sheets and at the same time keep the amount of absolutely necessary changes within the allowed pecuniary limits.

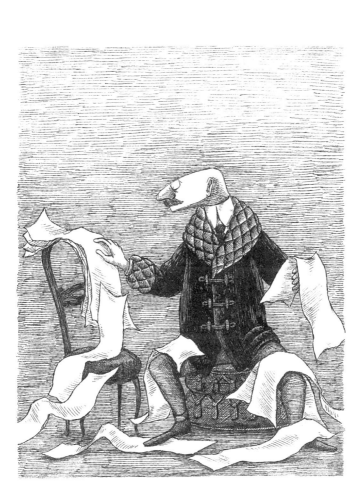

Mr Earbrass has received the sketch for the dust-wrapper of *TUH*. Even after staring at it continuously for twenty minutes, he really cannot believe it. Whatever were they thinking of? That drawing. Those colours. *Ugh*. On any book it would be ugly, vulgar, and illegible. On his book it would be these, and also disastrously wrong. Mr Earbrass looks forward to an exhilarating hour of conveying these sentiments to Scuffle and Dustcough.

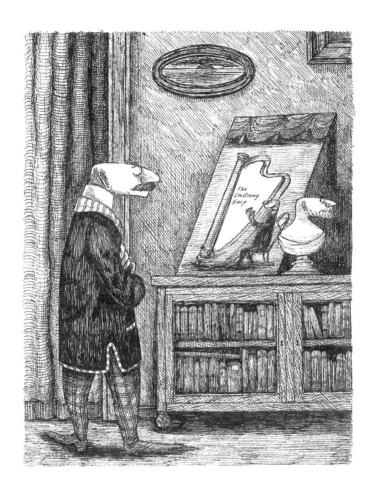

Things continued to come, this time Mr Earbrass's six free copies of *TUH*. There are, alas, at least three times that number of people who expect to receive one of them. Buying the requisite number of additional copies does not happen to be the solution, as it would come out almost at once, and everyone would be very angry at his wanton distribution of them to just anyone, and write him little notes of thanks ending with the remark that *TUH* seems rather down from your usual level of polish but then you were probably in a hurry for the money. If it didn't come out, the list would be three times larger for his next book.

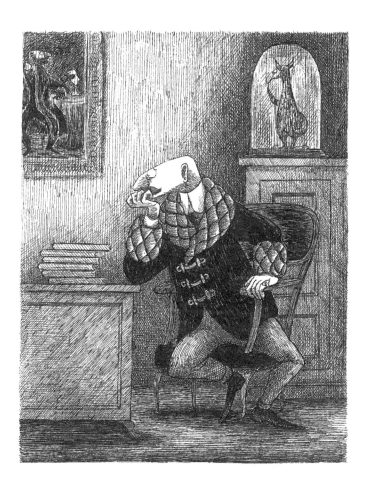

To-day *TUH* is published, and Mr Earbrass has come into Nether Millstone to do some errands which could not be put off any longer. He has been uncharacteristically thorough about doing them, and it is late afternoon before he pauses in front of a bookseller's window on the way back to his car. Having made certain, out of the corner of his eye, a copy of *TUH* was in it, he is carefully reading the title of every other book there in a state of extreme and pointless embarrassment.

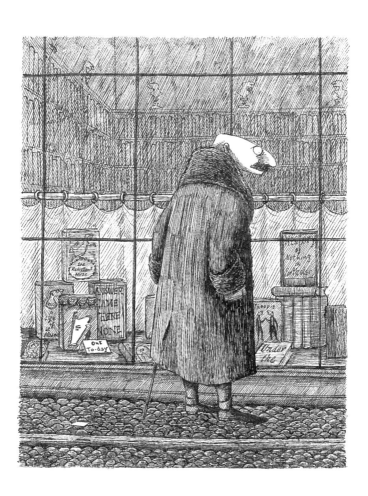

Scuffle and Dustcough have thoughtfully, if gratuitously, sent all the papers with reviews in them. They make a gratifyingly large heap. Mr Earbrass refuses to be intimidated into rushing through them, but he is having a certain amount of difficulty in concentrating on, or, rather, making any sense whatever out of, *A Compendium of the Minor Heresies of the Twelfth Century in Asia Minor*. He has been meaning to finish it ever since he began it two years and seven months before, at which time he bogged down on page 33.

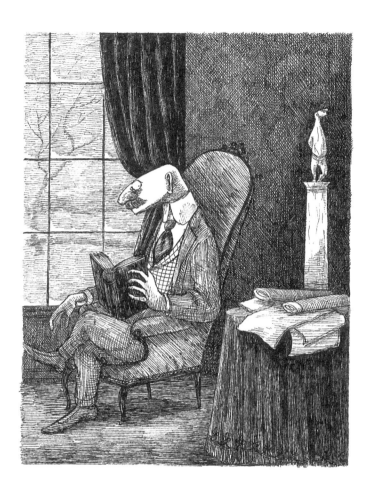

At an afternoon forgathering at the Vicarage vaguely in Mr Earbrass's honor, where he has been busy handing round cups of tea, he is brought up short by Col Knout, M.F.H. of the Blathering Hunt. He demands to know just what Mr Earbrass was 'getting at' in the last scene of Chapter XIV. Mr Earbrass is afraid he doesn't know what the Colonel is. Is what? Getting at himself. The Colonel snorts, Mr Earbrass sighs. This encounter, which will go on for some time and get nowhere, will leave Mr Earbrass feeling very weak indeed.

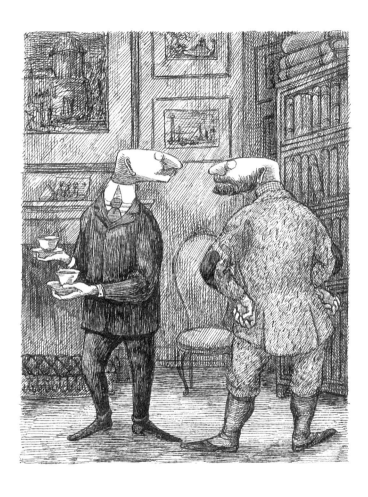

Mr Earbrass stands on the terrace at twilight. It is bleak; it is cold; and the virtue has gone out of everything. Words drift through his mind: ANGUISH TURNIPS CONJUNCTIONS ILLNESS DEFEAT STRING PARTIES NO PARTIES URNS DESUETUDE DISAF-FECTION CLAWS LOSS TREBIZOND NAPKINS SHAME STONES DISTANCE FEVER ANTIPODES MUSH GLA-CIERS INCOHERENCE LABELS MIASMA AMPUTA-TION TIDES DECEIT MOURNING ELSEWARDS ...

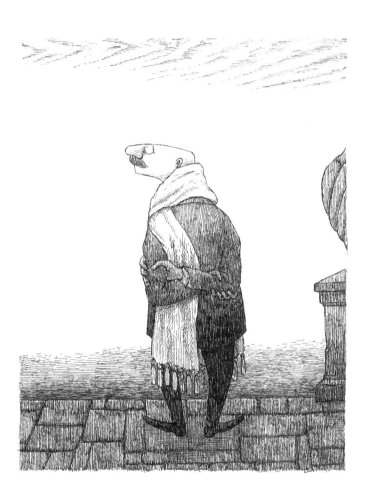

Before he knew what he was doing, Mr Earbrass found he had every intention of spending a few weeks on the Continent. In a trance of efficiency, which could have surprised no-one more than himself, he made the complicated and maddening preparations for his departure in no time at all. Now, at dawn, he stands, quite numb with cold and trepidation, looking at the churning surface of the Channel. He assumes he will be horribly sick for hours and hours, but it doesn't matter. Though he is a person to whom things do not happen, perhaps they may when he is on the other side.

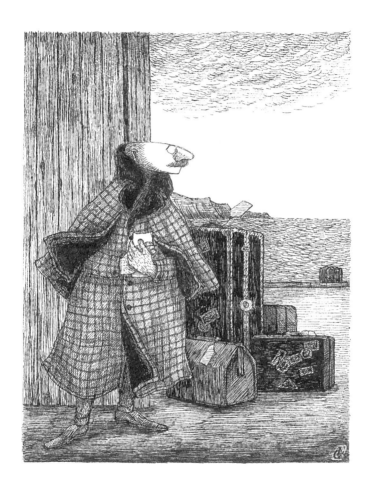